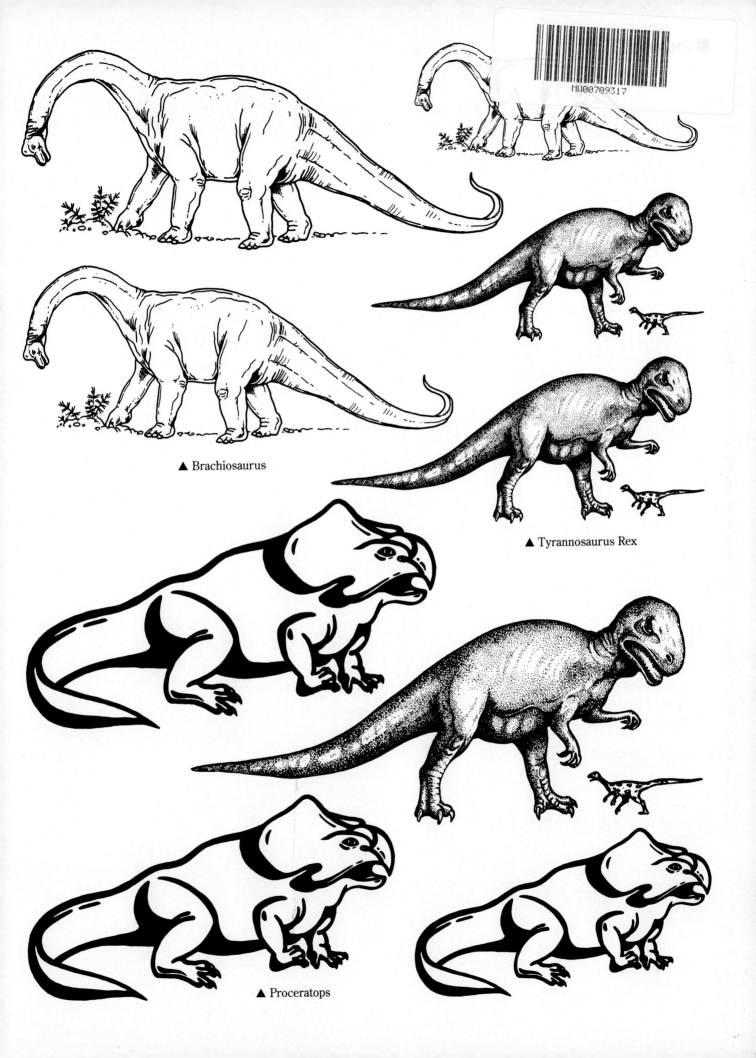

▲ Brachiosaurus

▲ Tyrannosaurus Rex

▲ Proceratops

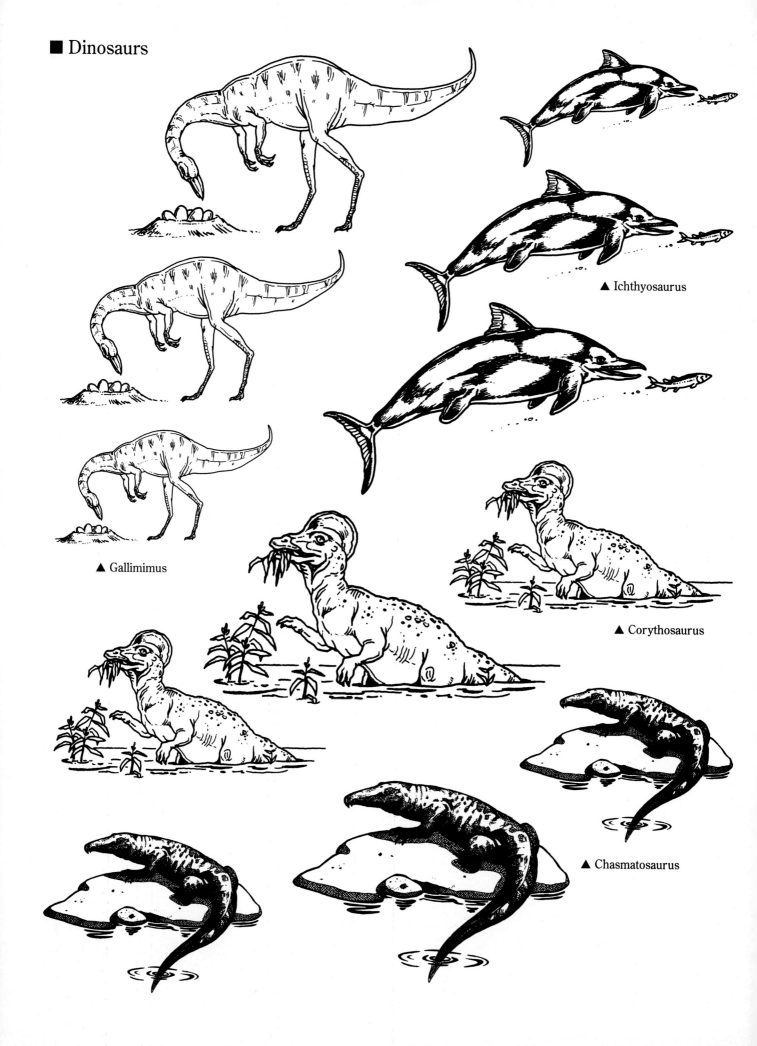

■ Dinosaurs

▲ Ichthyosaurus

▲ Gallimimus

▲ Corythosaurus

▲ Chasmatosaurus

▲ Dimorphodon

▲ Archueopteryx

▲ Pachycephalosaurus

▲ Megalosaurus

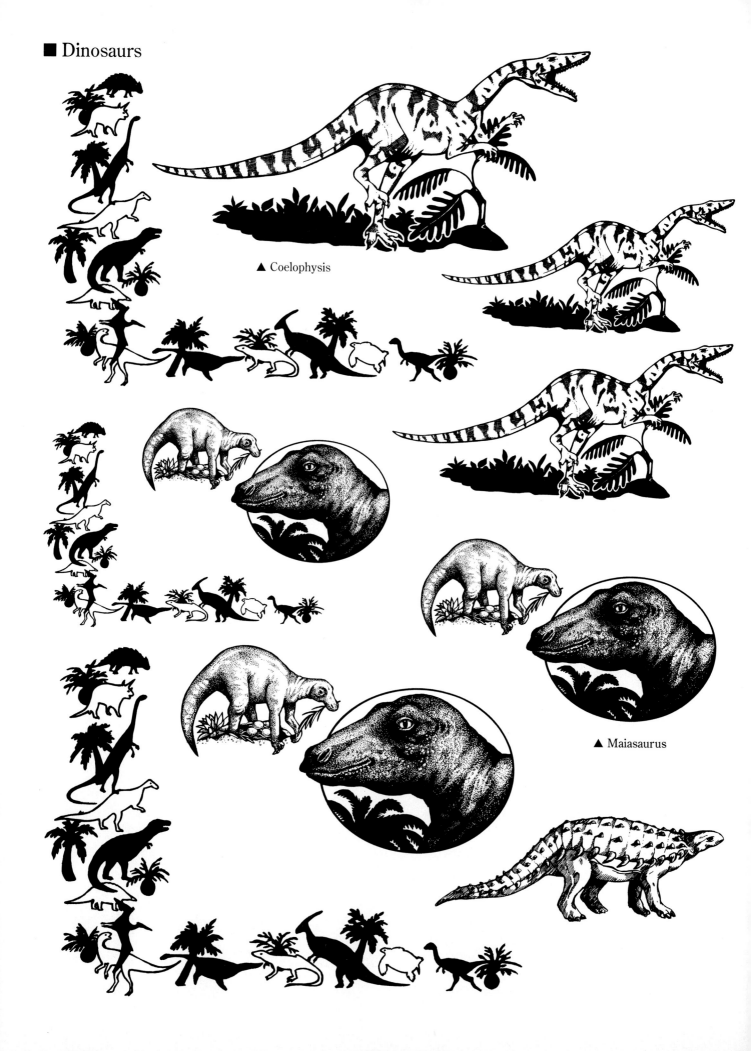

■ Dinosaurs

▲ Coelophysis

▲ Maiasaurus

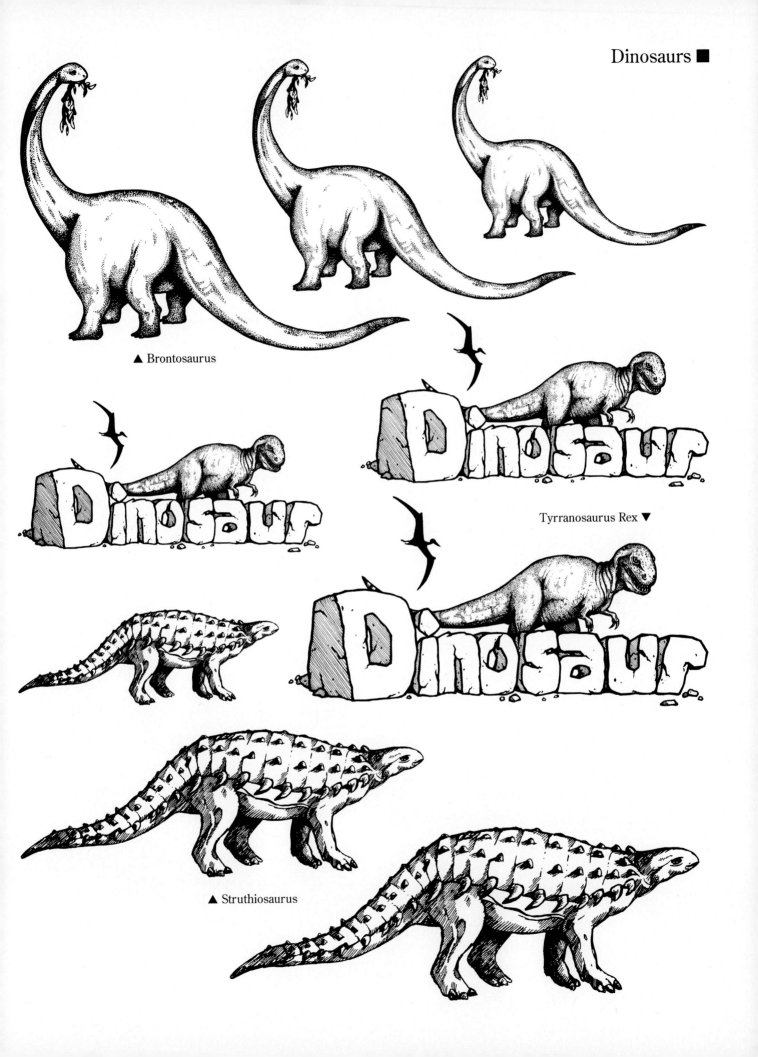

▲ Brontosaurus

Tyrranosaurus Rex ▼

▲ Struthiosaurus

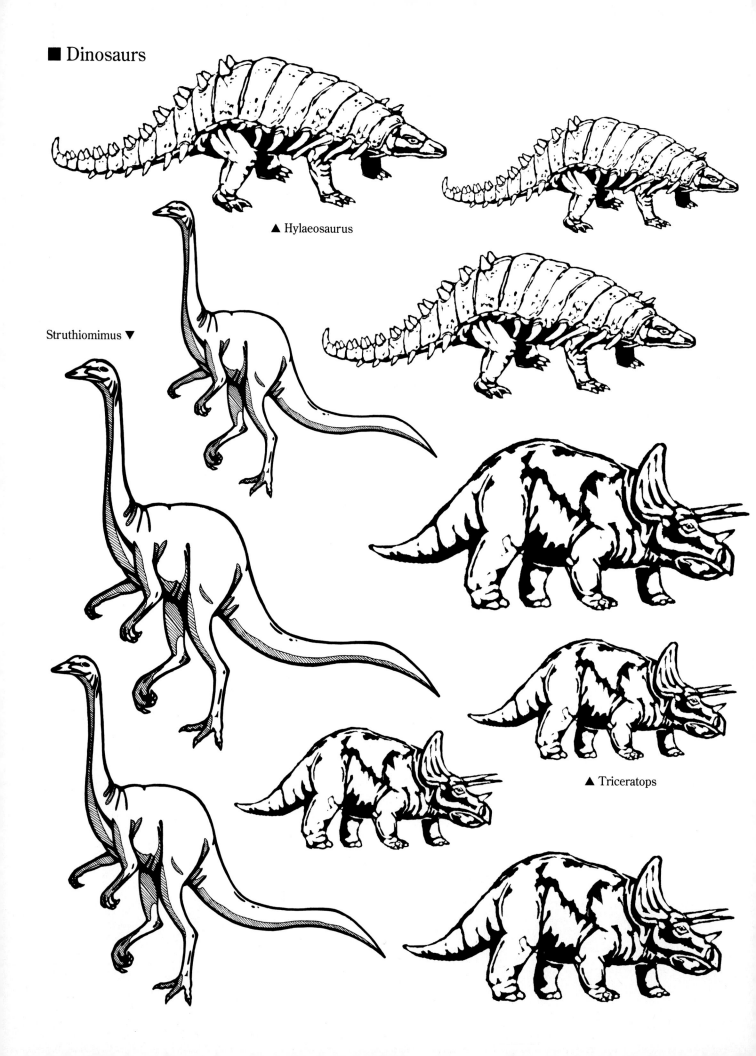

■ Dinosaurs

▲ Hylaeosaurus

Struthiomimus ▼

▲ Triceratops

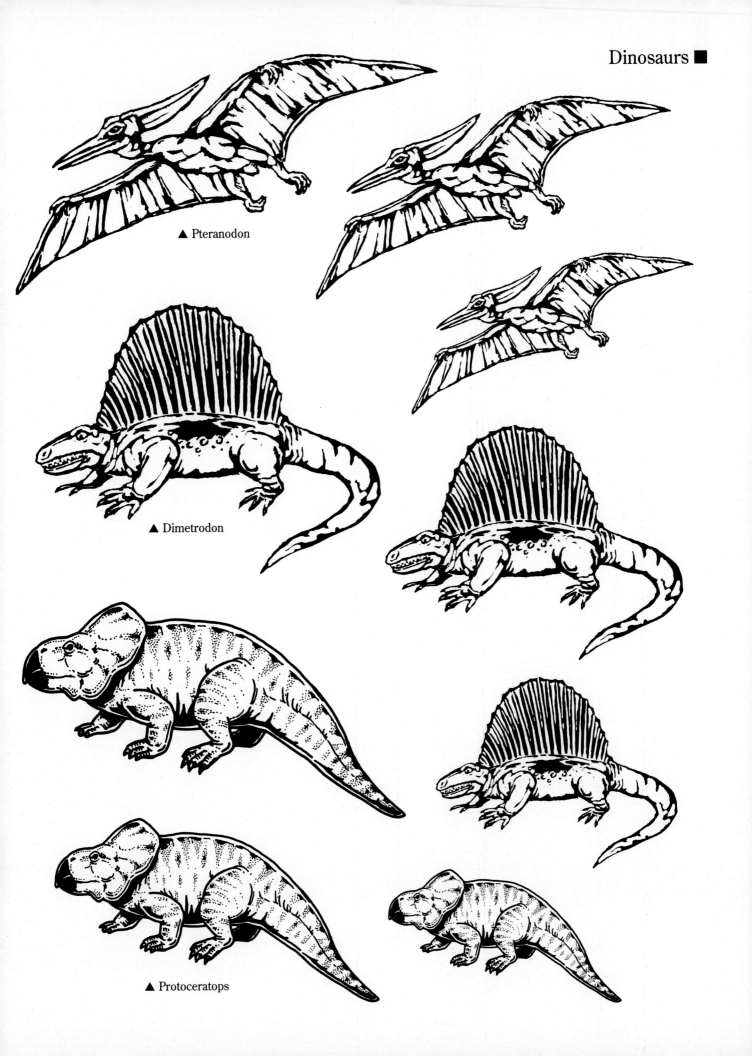

▲ Pteranodon

▲ Dimetrodon

▲ Protoceratops

■ Dinosaurs

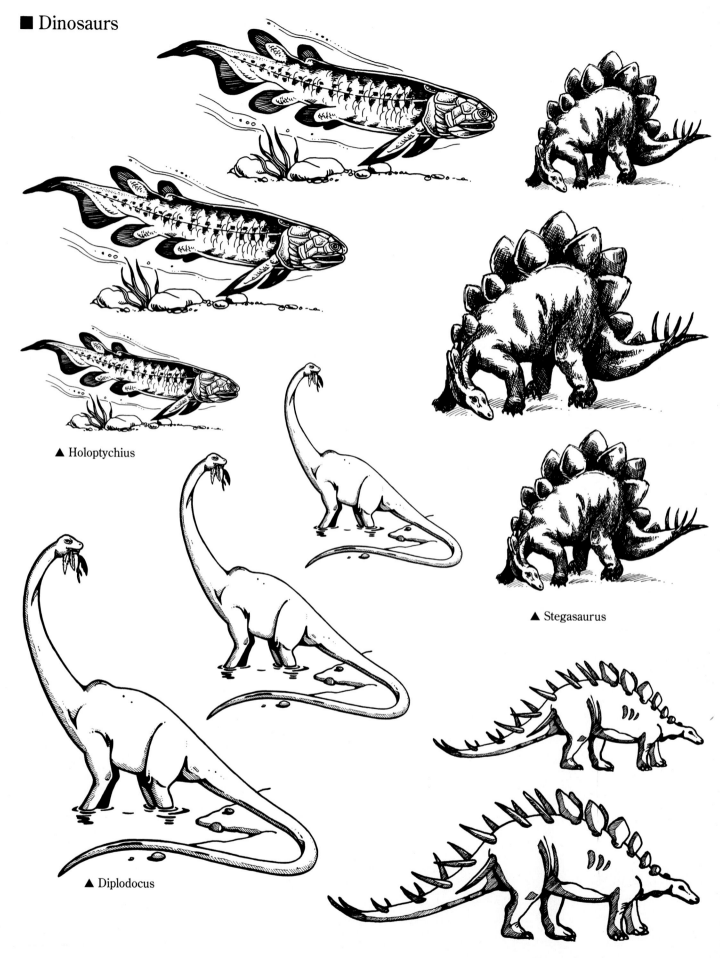

▲ Holoptychius

▲ Diplodocus

▲ Stegasaurus

▲ Kentrosaurus

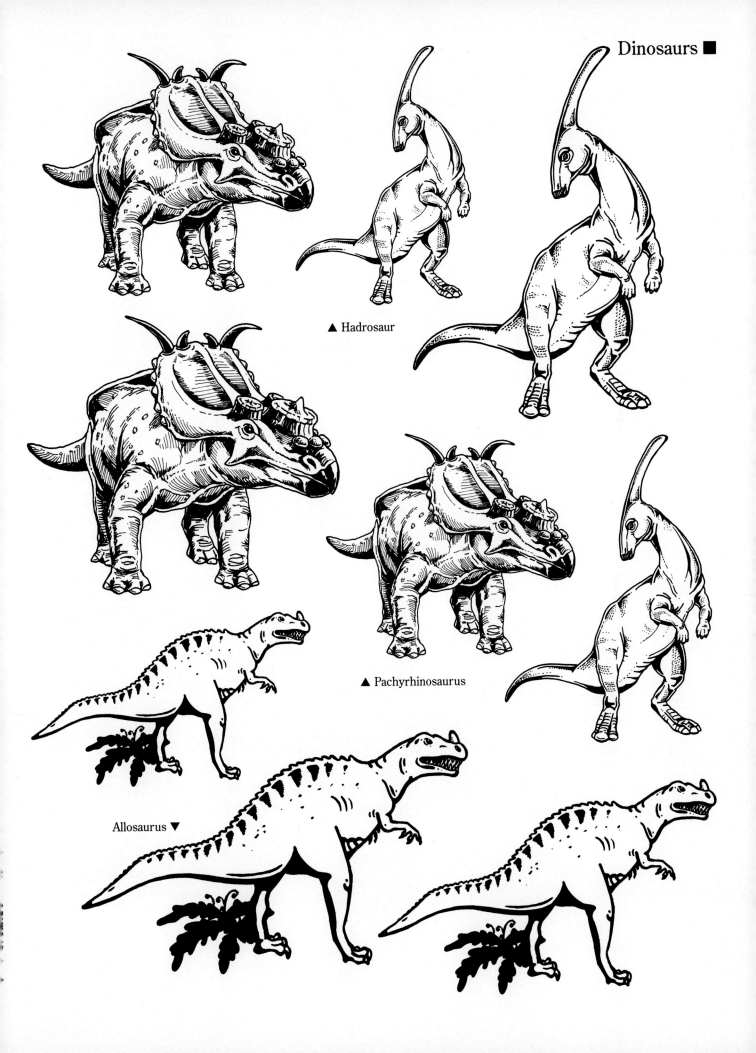

▲ Hadrosaur

▲ Pachyrhinosaurus

Allosaurus ▼

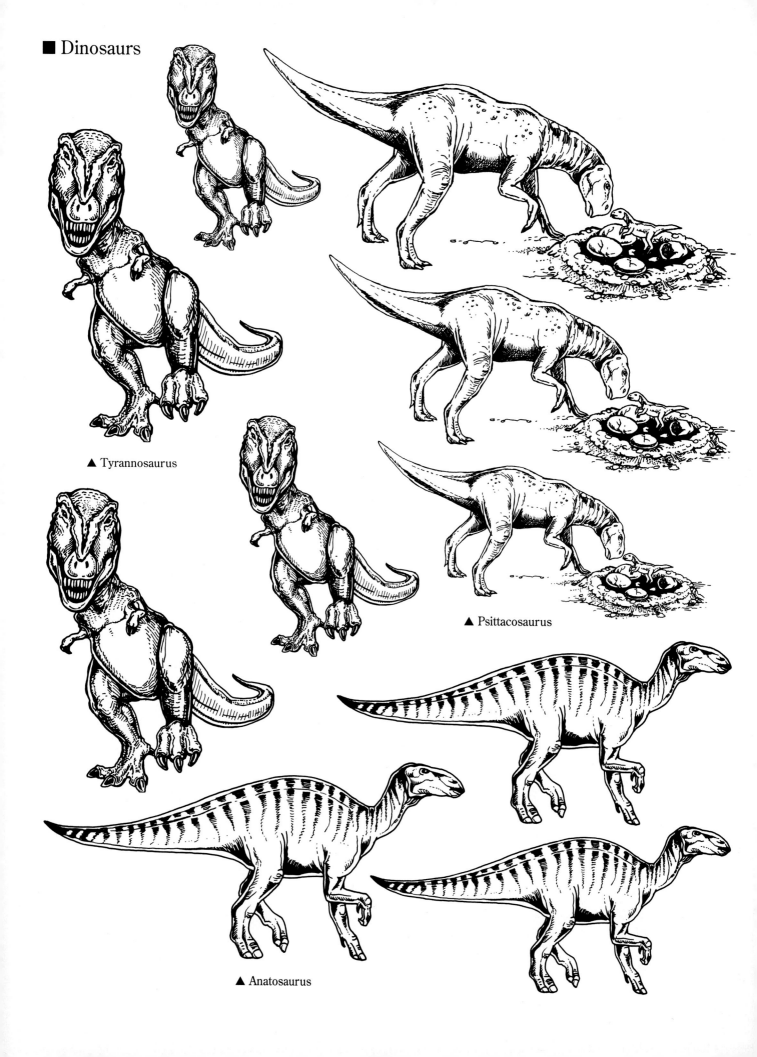

■ Dinosaurs

▲ Tyrannosaurus

▲ Psittacosaurus

▲ Anatosaurus

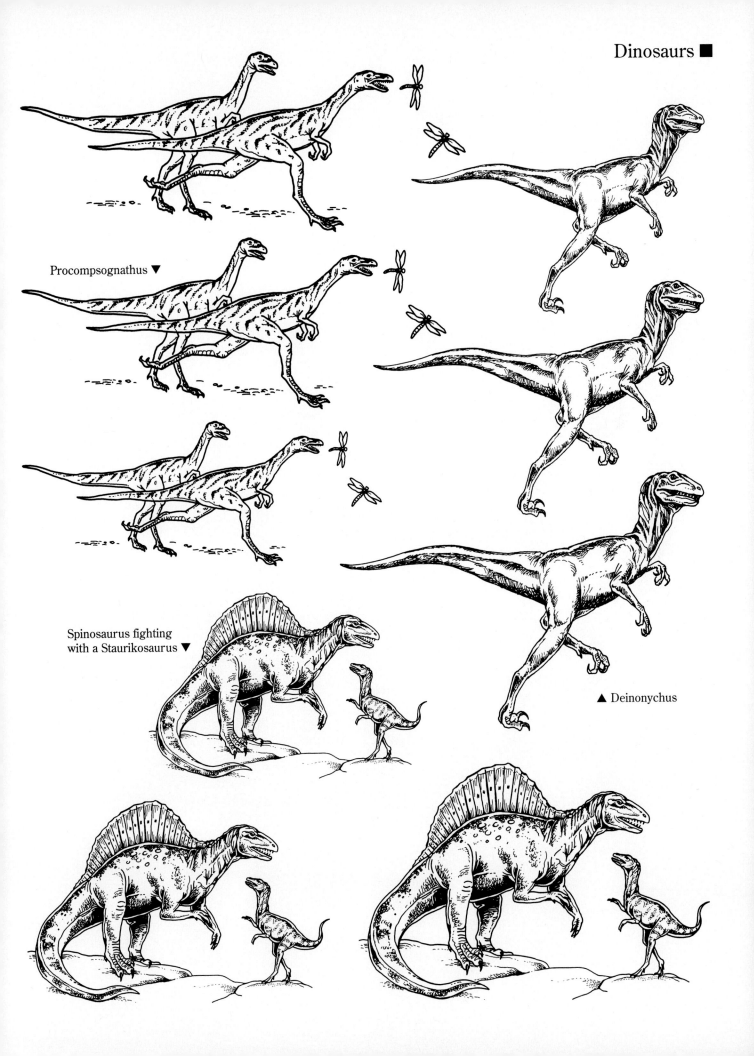

Procompsognathus ▼

Spinosaurus fighting
with a Staurikosaurus ▼

▲ Deinonychus

■ Dinosaurs

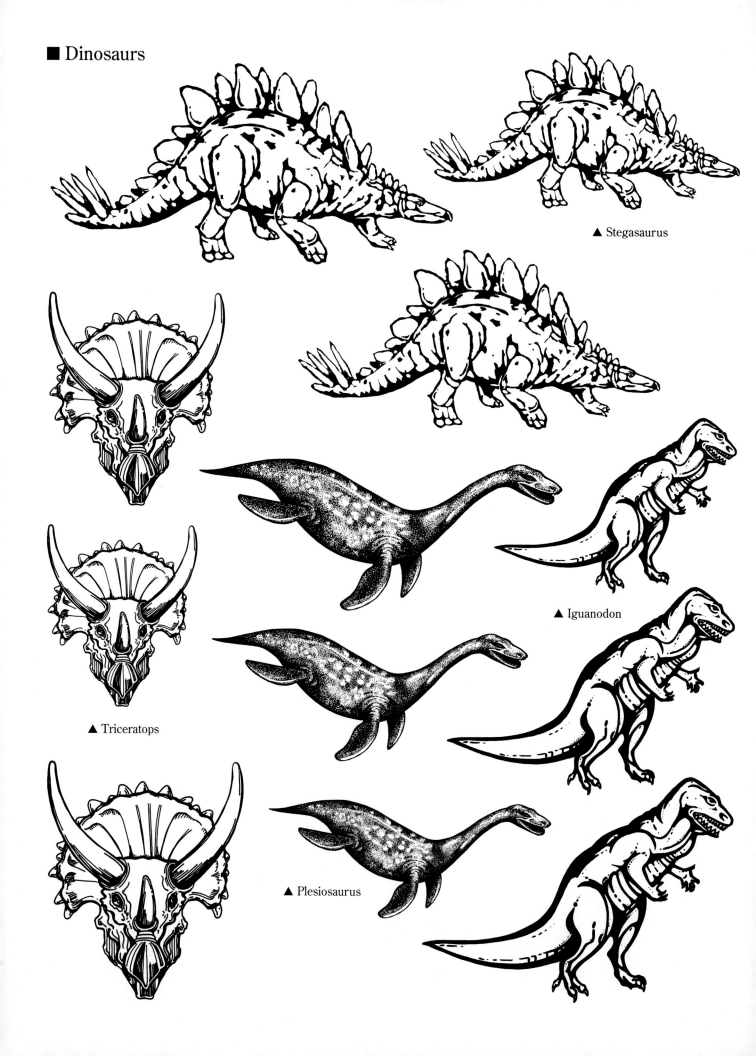

▲ Stegasaurus

▲ Triceratops

▲ Plesiosaurus

▲ Iguanodon

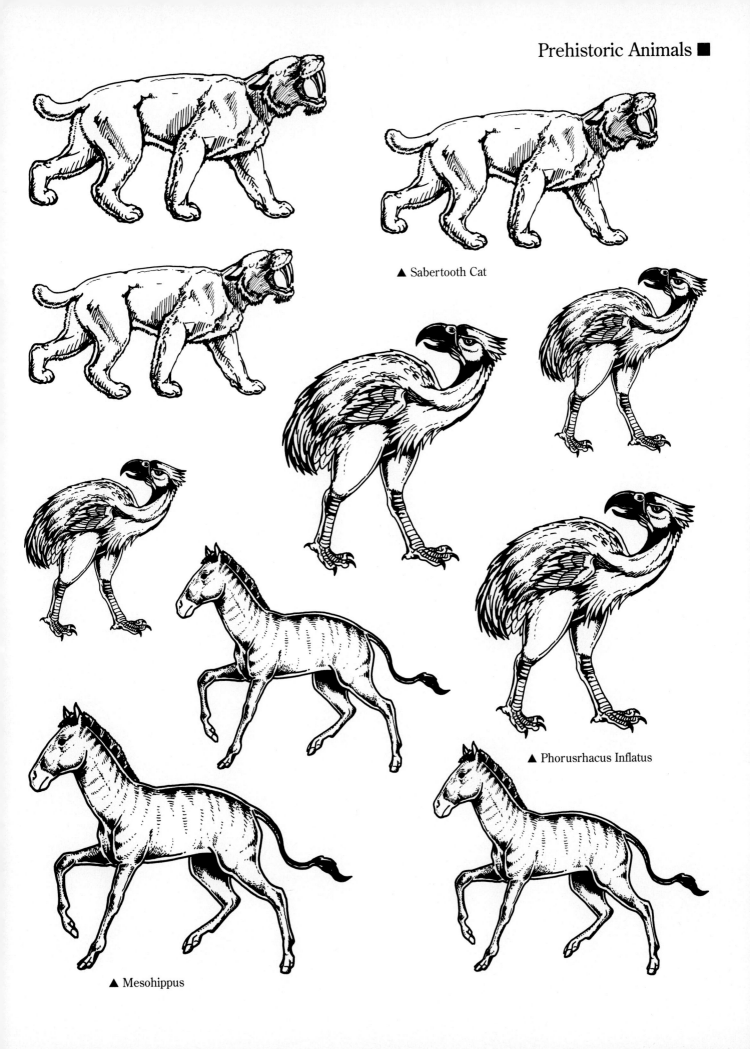

▲ Sabertooth Cat

▲ Phorusrhacus Inflatus

▲ Mesohippus

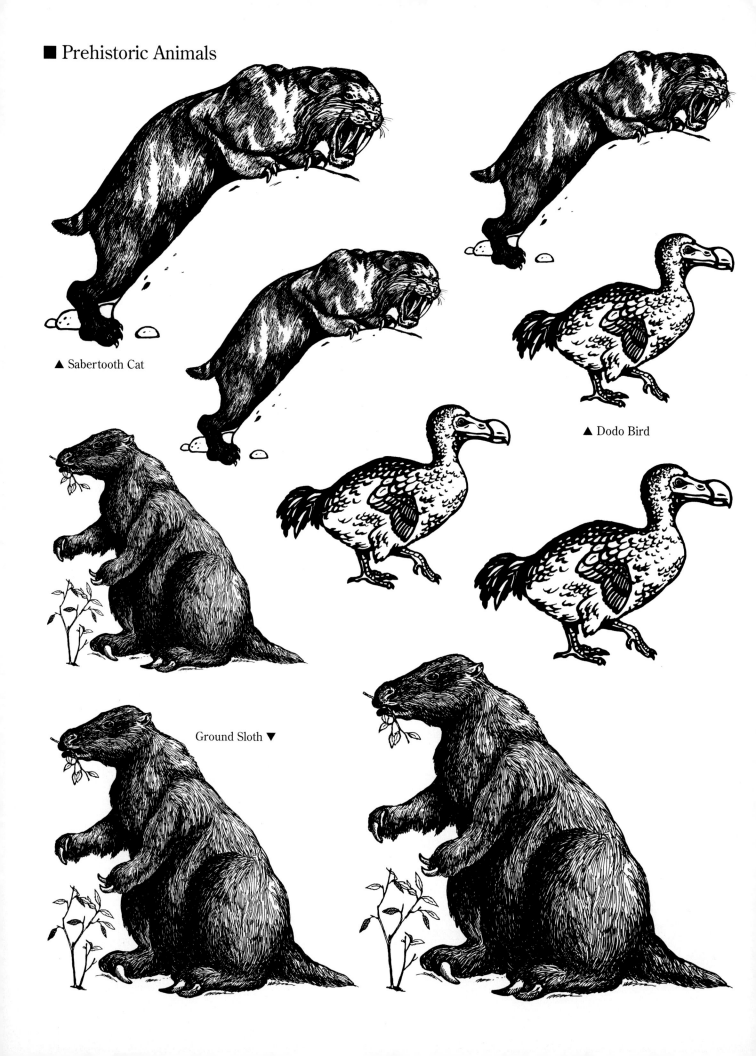

■ Prehistoric Animals

▲ Sabertooth Cat

▲ Dodo Bird

Ground Sloth ▼

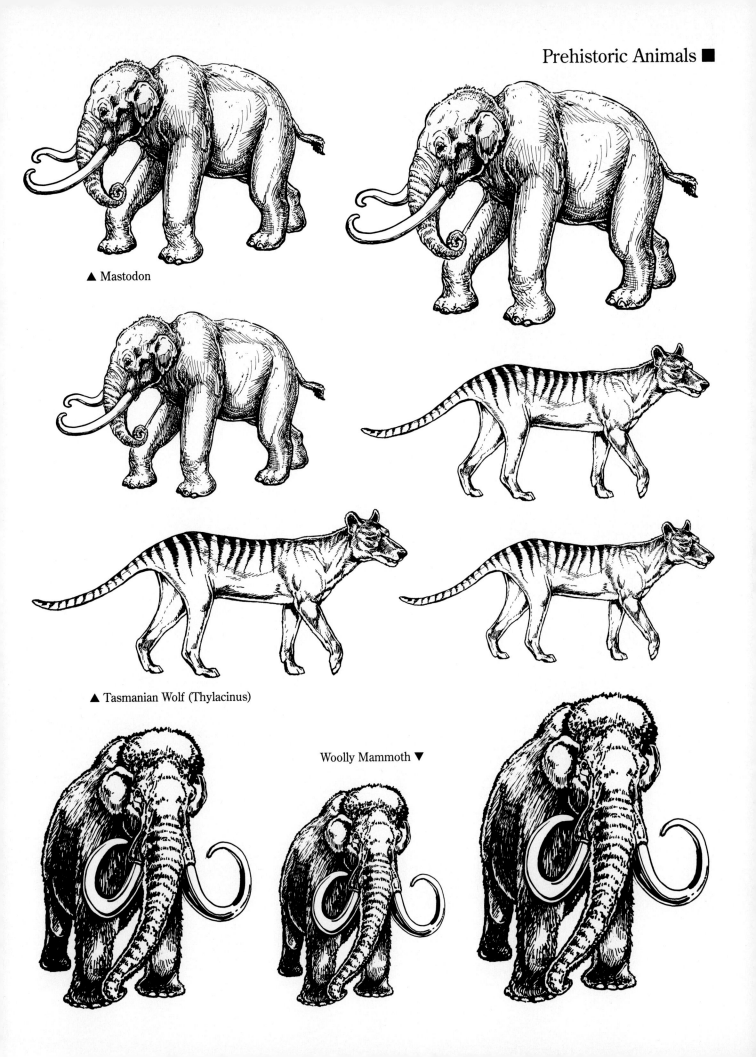

▲ Mastodon

▲ Tasmanian Wolf (Thylacinus)

Woolly Mammoth ▼

■ Rare Mammals

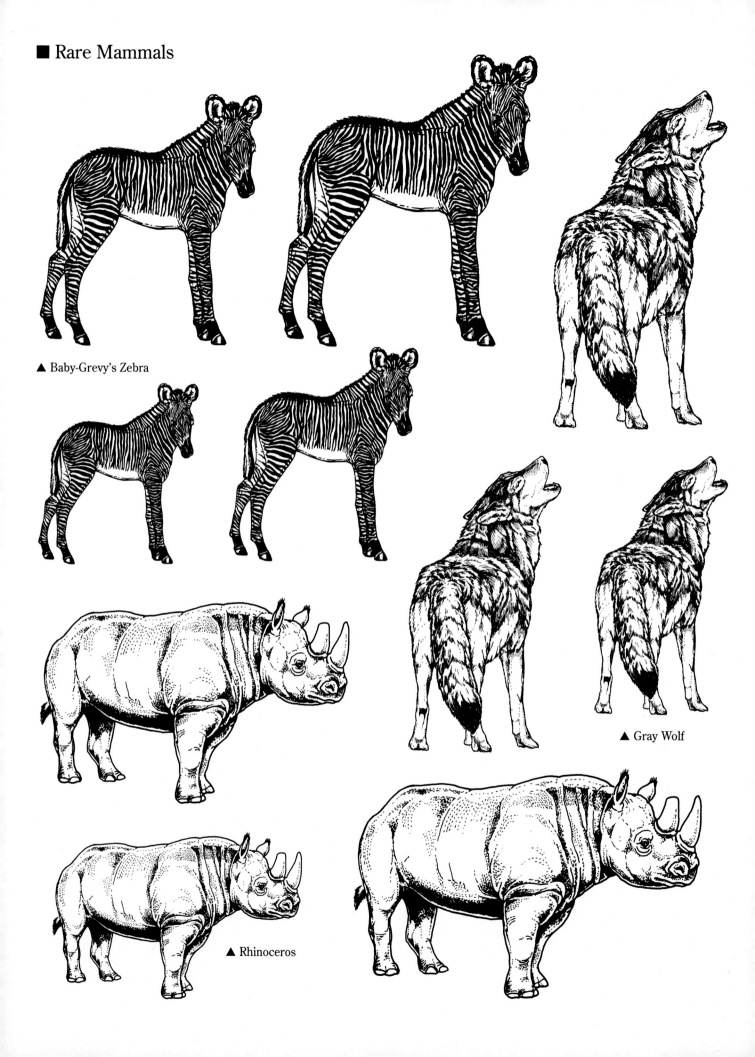

▲ Baby-Grevy's Zebra

▲ Gray Wolf

▲ Rhinoceros

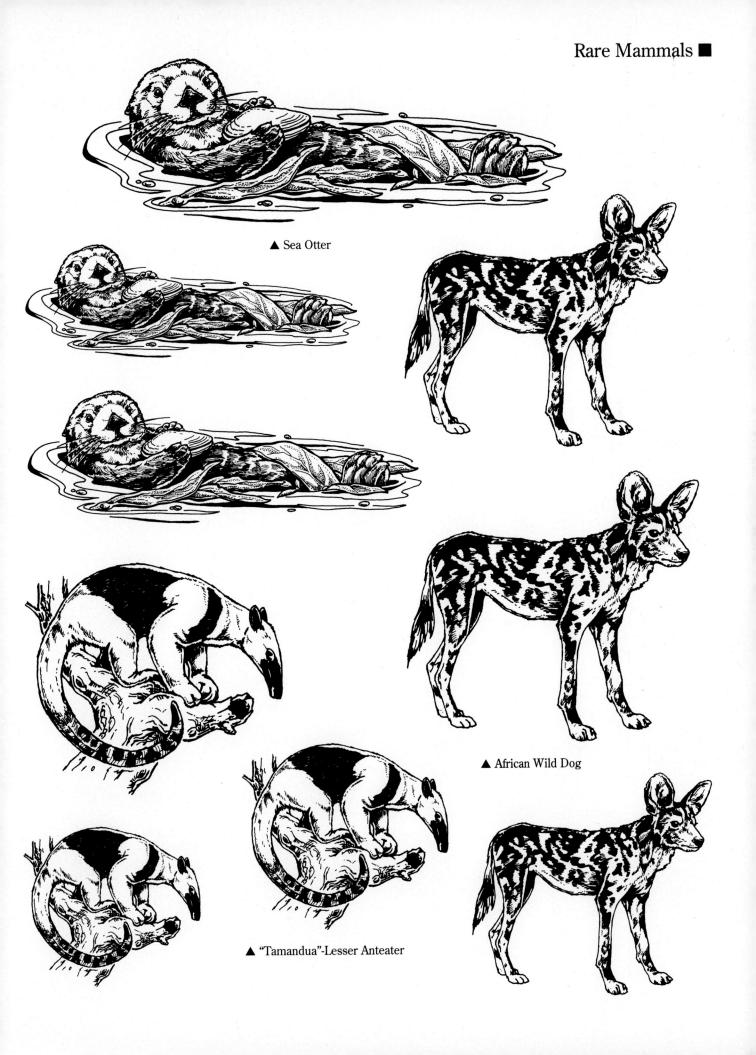

▲ Sea Otter

▲ African Wild Dog

▲ "Tamandua"-Lesser Anteater

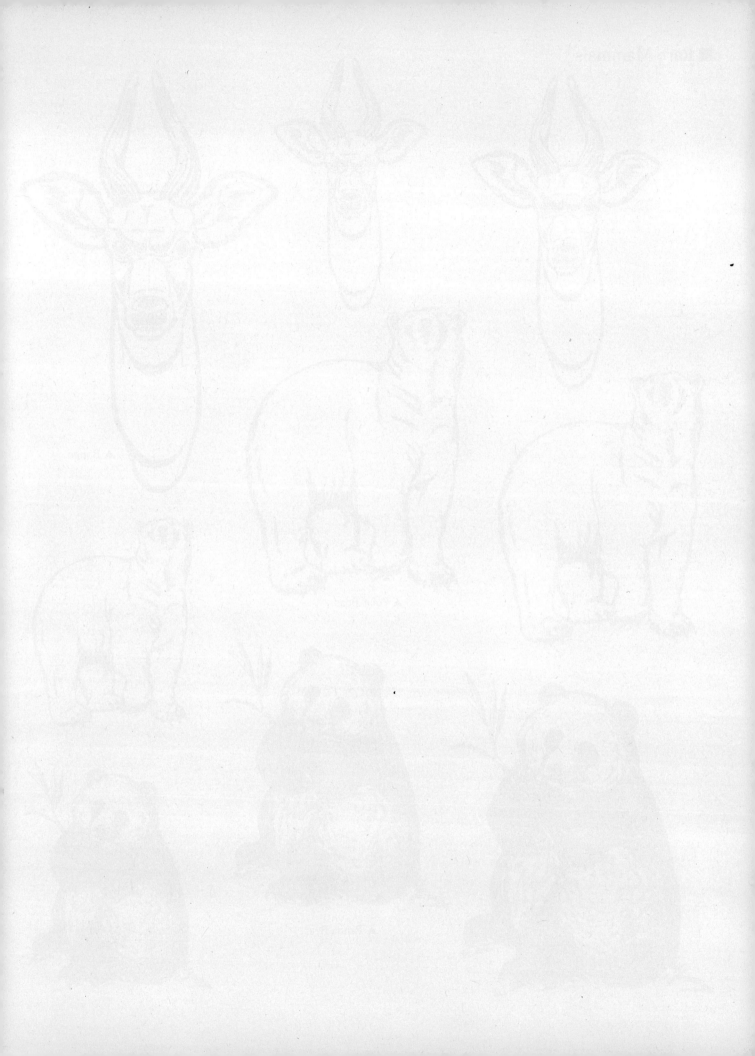

■ Rare Mammals

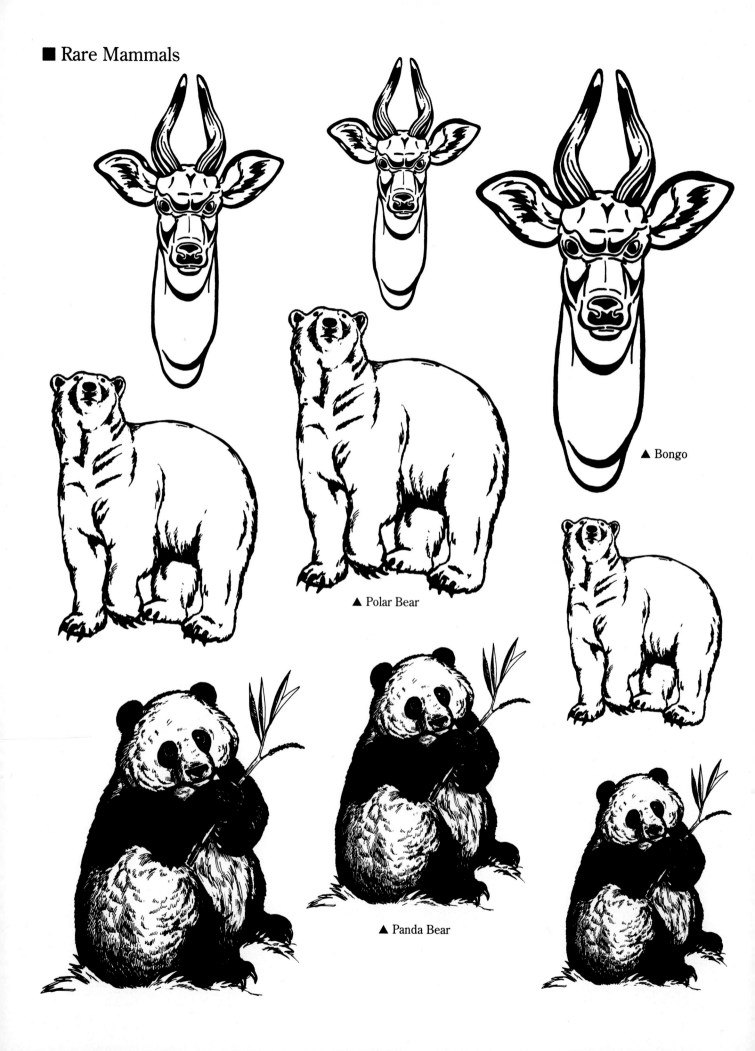

▲ Bongo

▲ Polar Bear

▲ Panda Bear

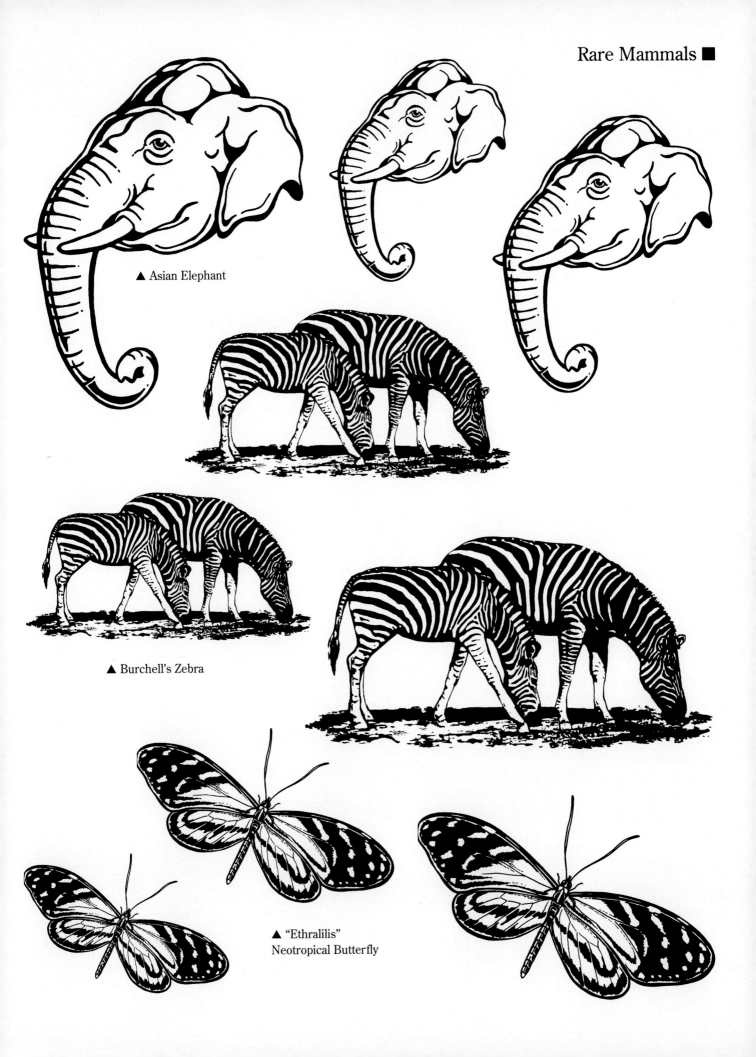

▲ Asian Elephant

▲ Burchell's Zebra

▲ "Ethralilis"
Neotropical Butterfly

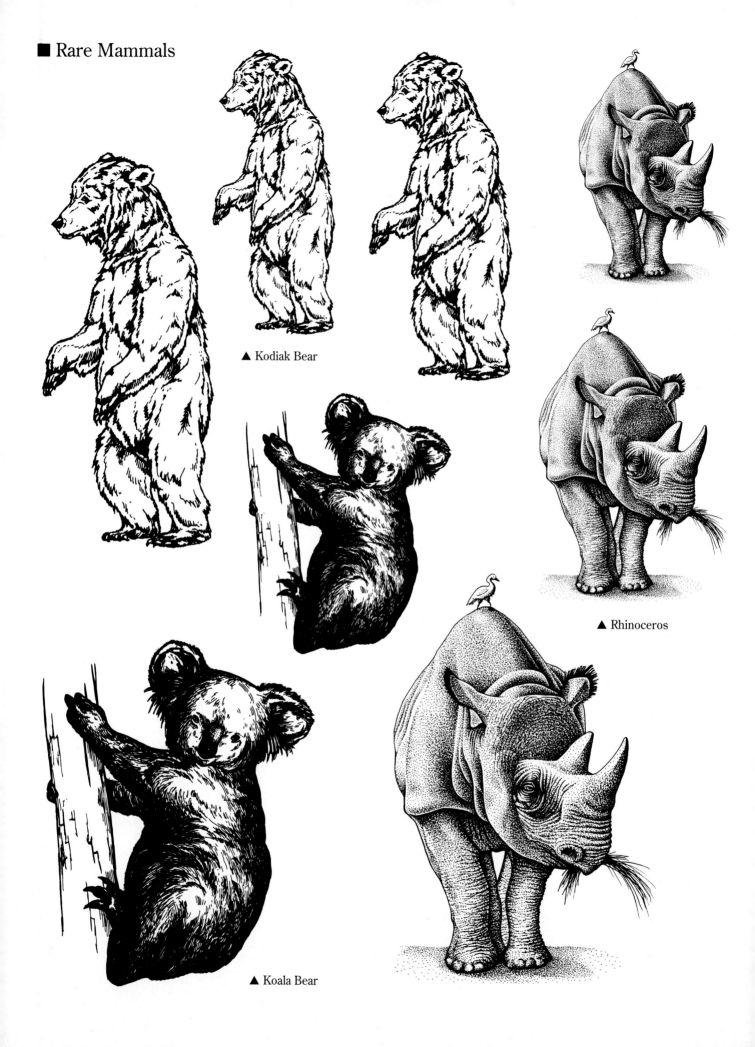

■ Rare Mammals

▲ Kodiak Bear

▲ Rhinoceros

▲ Koala Bear

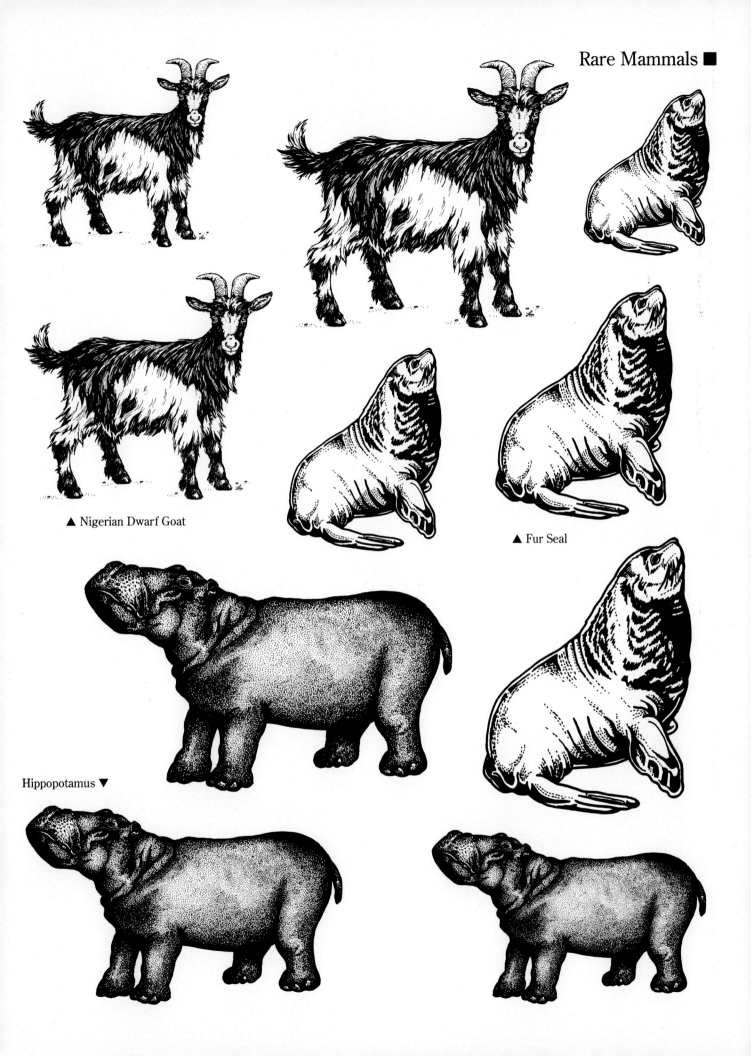

Rare Mammals ■

▲ Nigerian Dwarf Goat

▲ Fur Seal

Hippopotamus ▼

■ Rare Primates

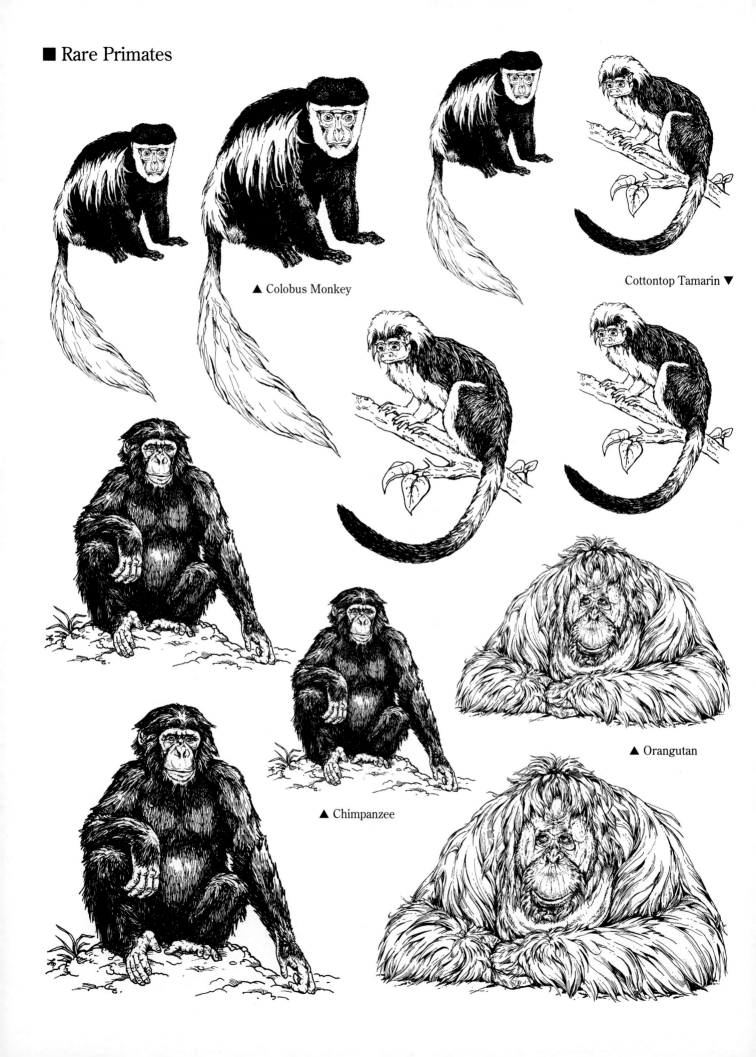

▲ Colobus Monkey

Cottontop Tamarin ▼

▲ Orangutan

▲ Chimpanzee

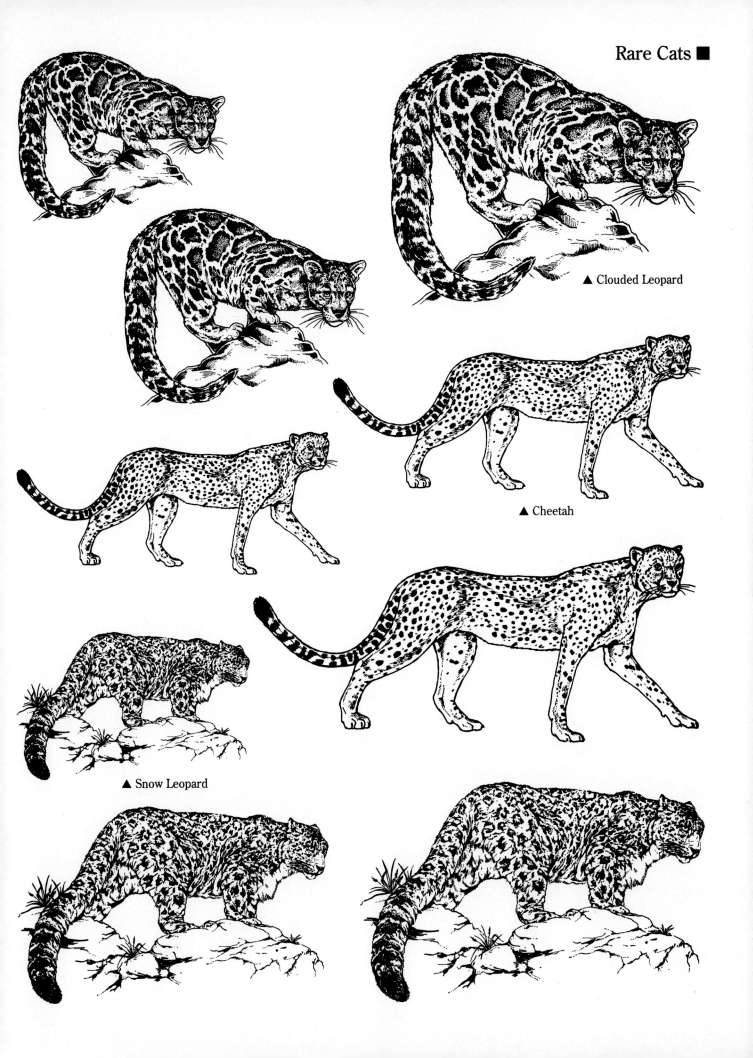

Rare Cats ■

▲ Clouded Leopard

▲ Cheetah

▲ Snow Leopard

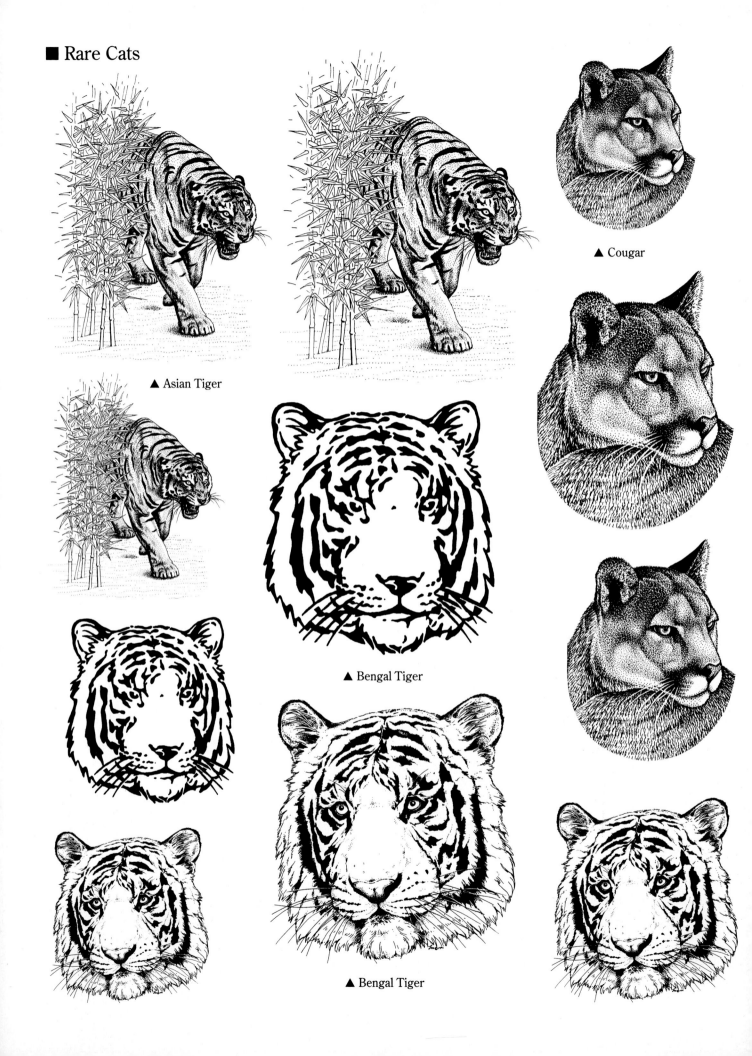

■ Rare Cats

▲ Asian Tiger

▲ Bengal Tiger

▲ Bengal Tiger

▲ Cougar

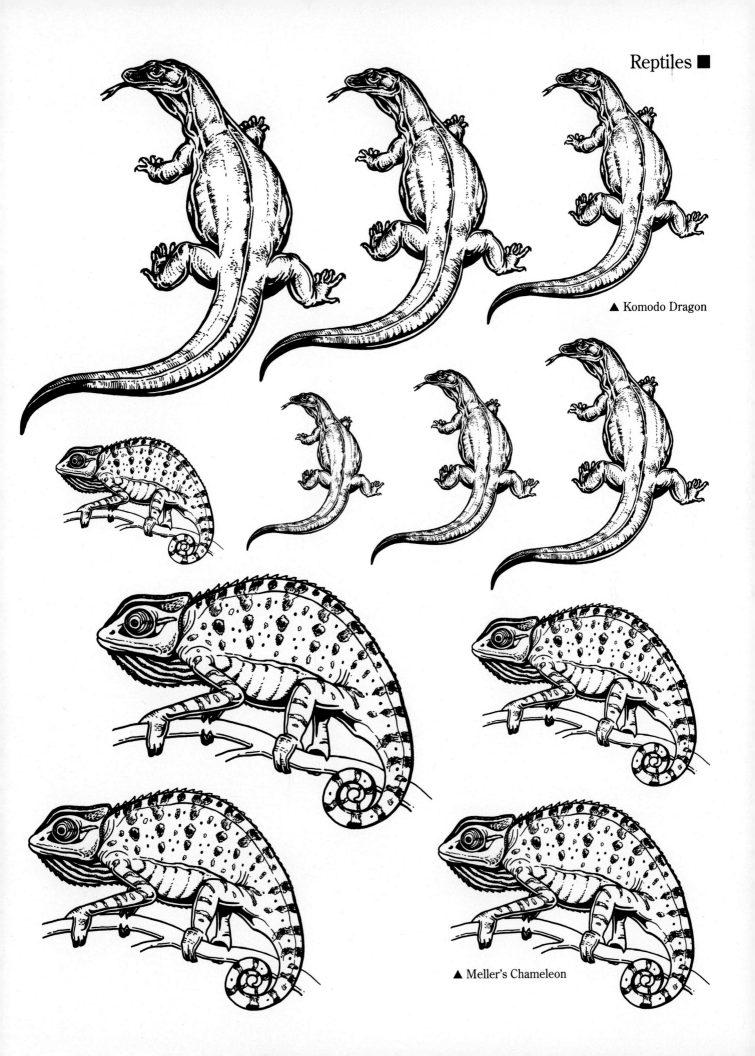

Reptiles ■

▲ Komodo Dragon

▲ Meller's Chameleon

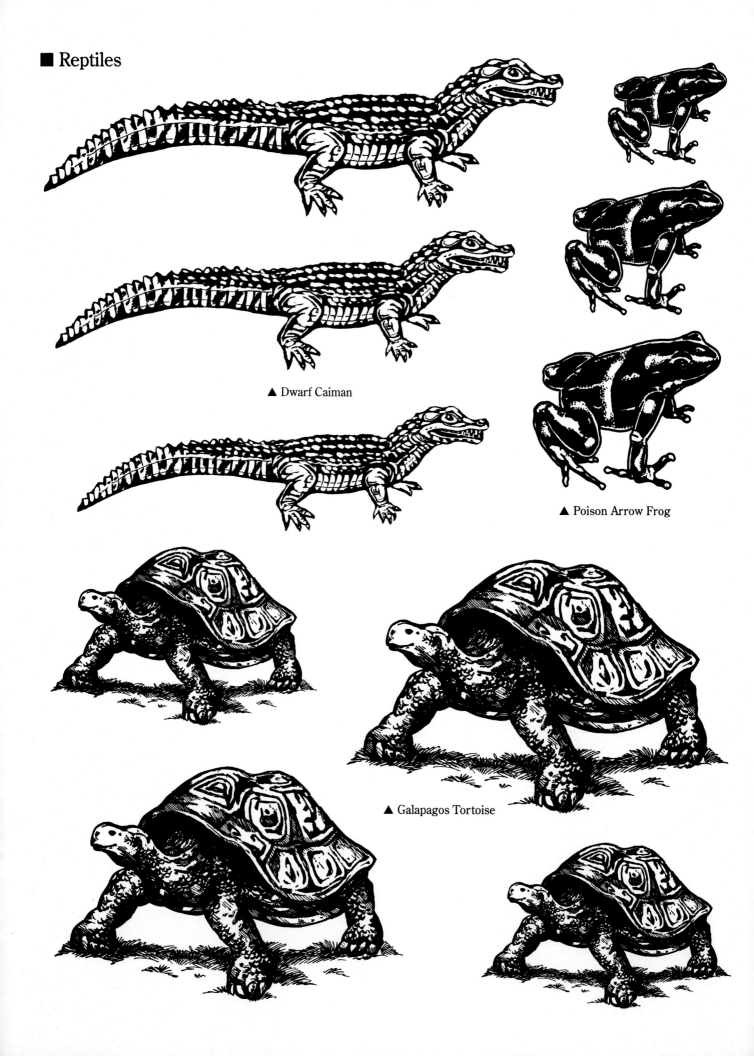

■ Reptiles

▲ Dwarf Caiman

▲ Poison Arrow Frog

▲ Galapagos Tortoise

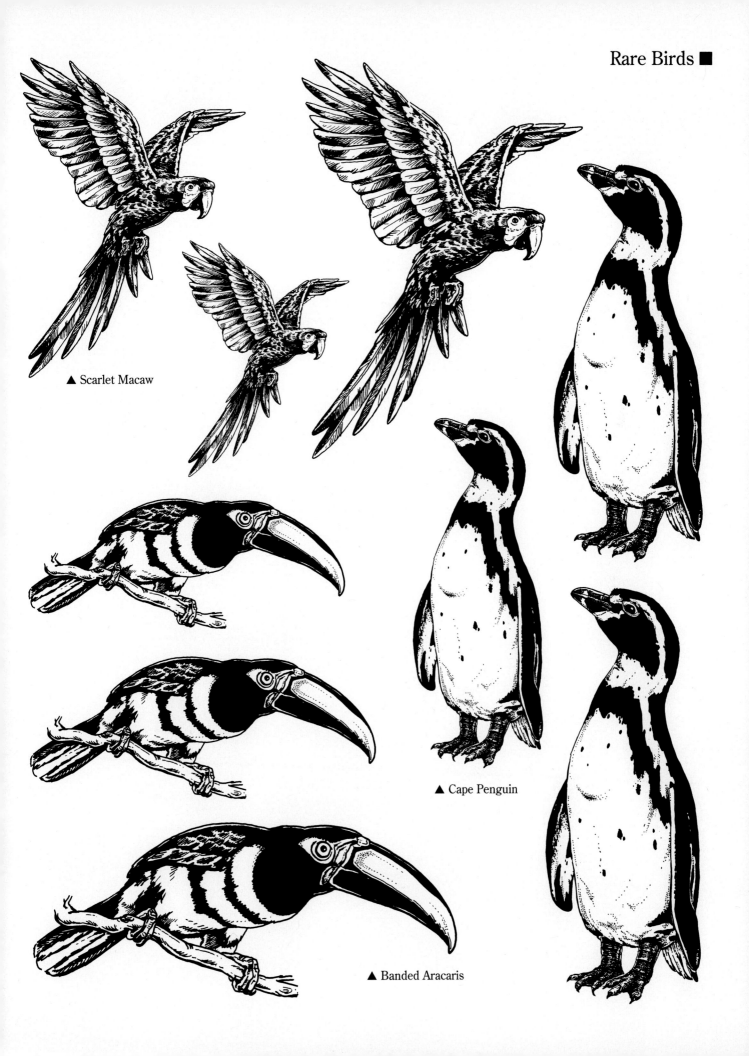

▲ Scarlet Macaw

▲ Cape Penguin

▲ Banded Aracaris

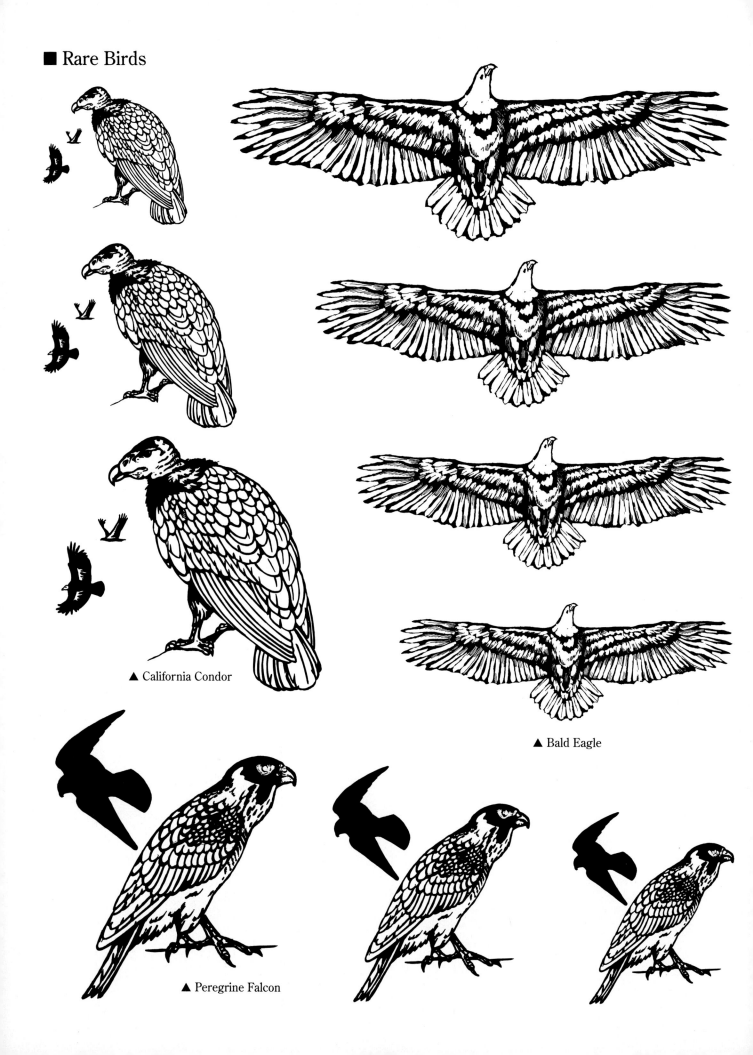

■ Rare Birds

▲ California Condor

▲ Bald Eagle

▲ Peregrine Falcon

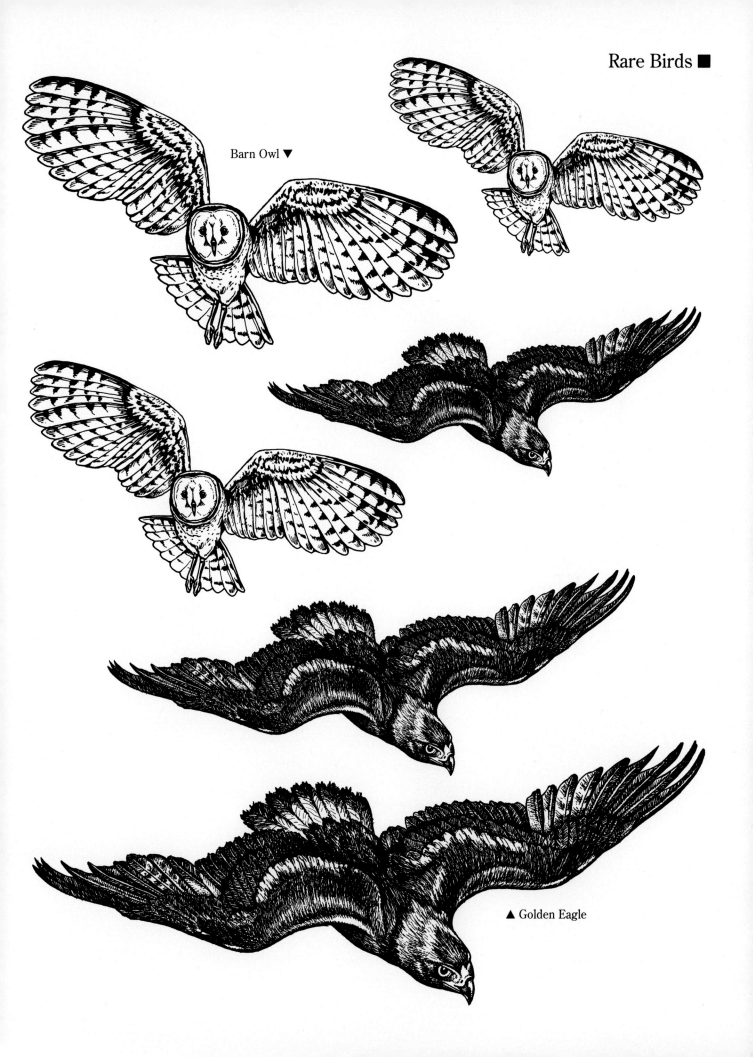

Rare Birds ■

Barn Owl ▼

▲ Golden Eagle

■ Sea Creatures

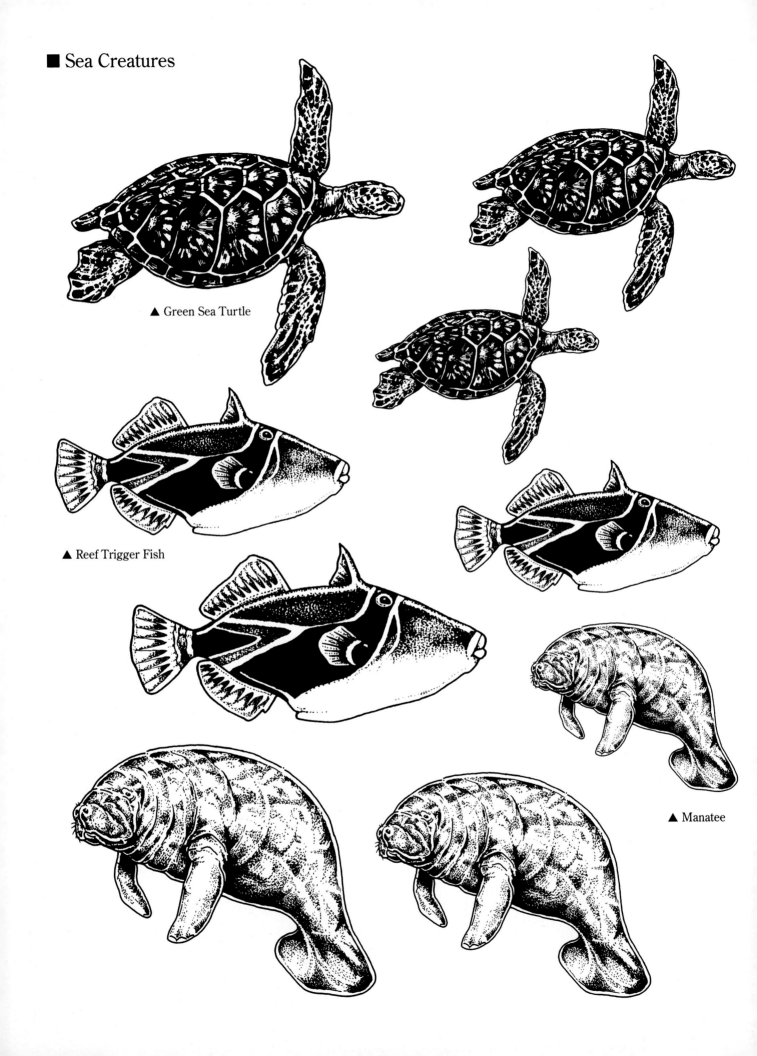

▲ Green Sea Turtle

▲ Reef Trigger Fish

▲ Manatee

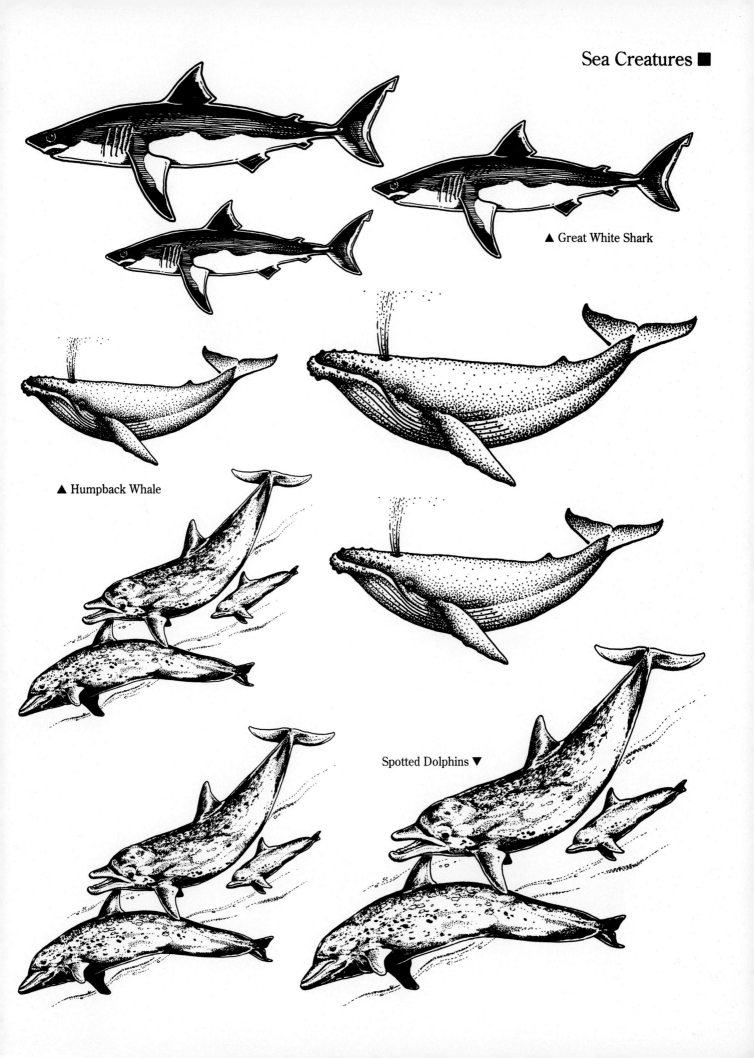

Sea Creatures ■

▲ Great White Shark

▲ Humpback Whale

Spotted Dolphins ▼

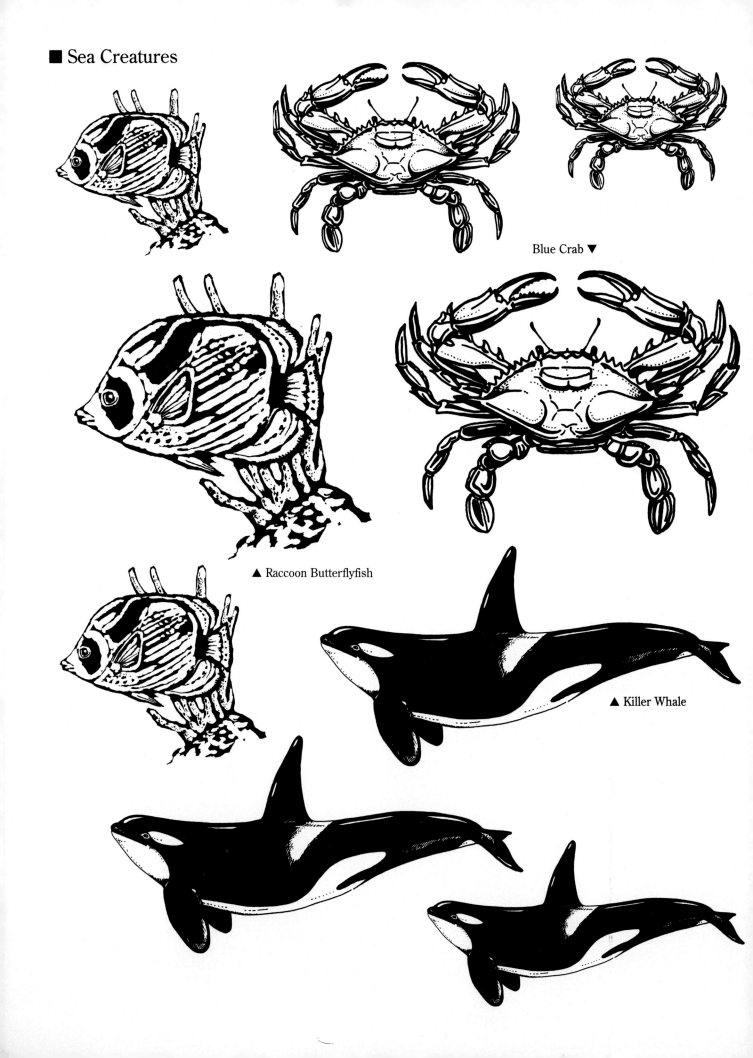

■ Sea Creatures

Blue Crab ▼

▲ Raccoon Butterflyfish

▲ Killer Whale